A VERY SIMPLE CHRISTMAS

Colorist

Dawn Merideth

For Mommie And Tween, Pages and Activities for the kiddos

Bring the Family Time back Together

Let Dad Chill-lax on the Sofa

COPYRIGHT PROTECTED ARTIST n.Mariahg

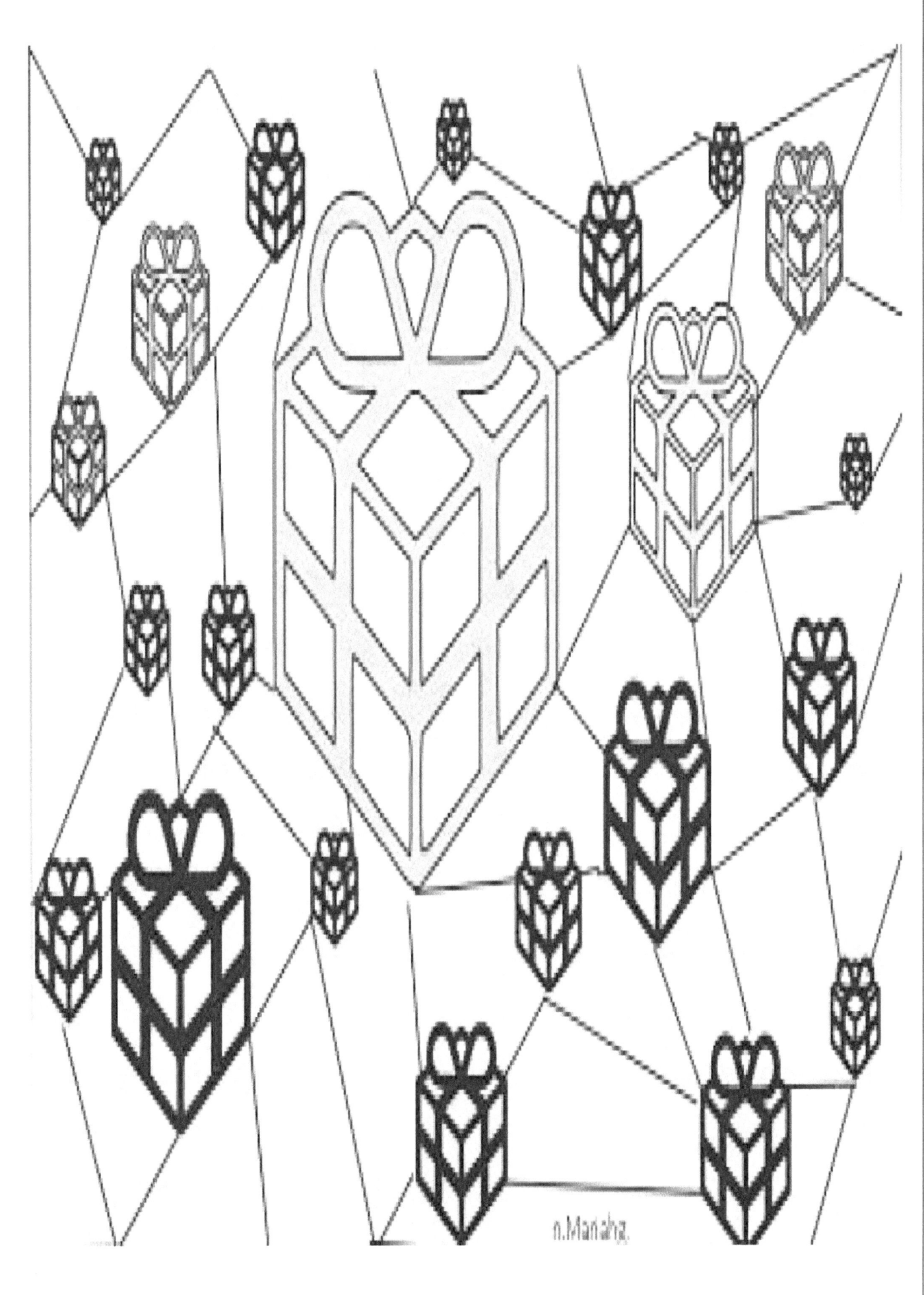

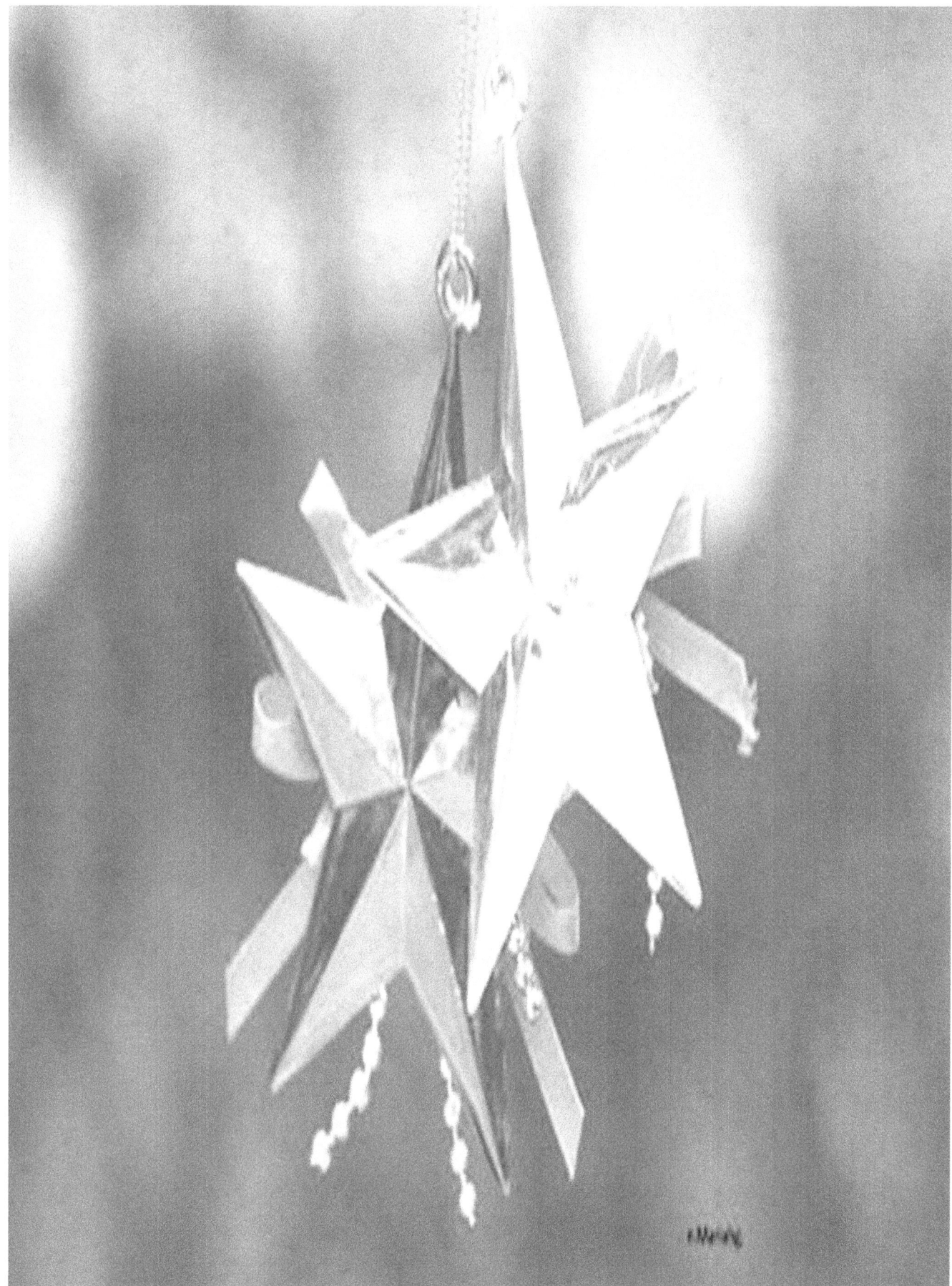

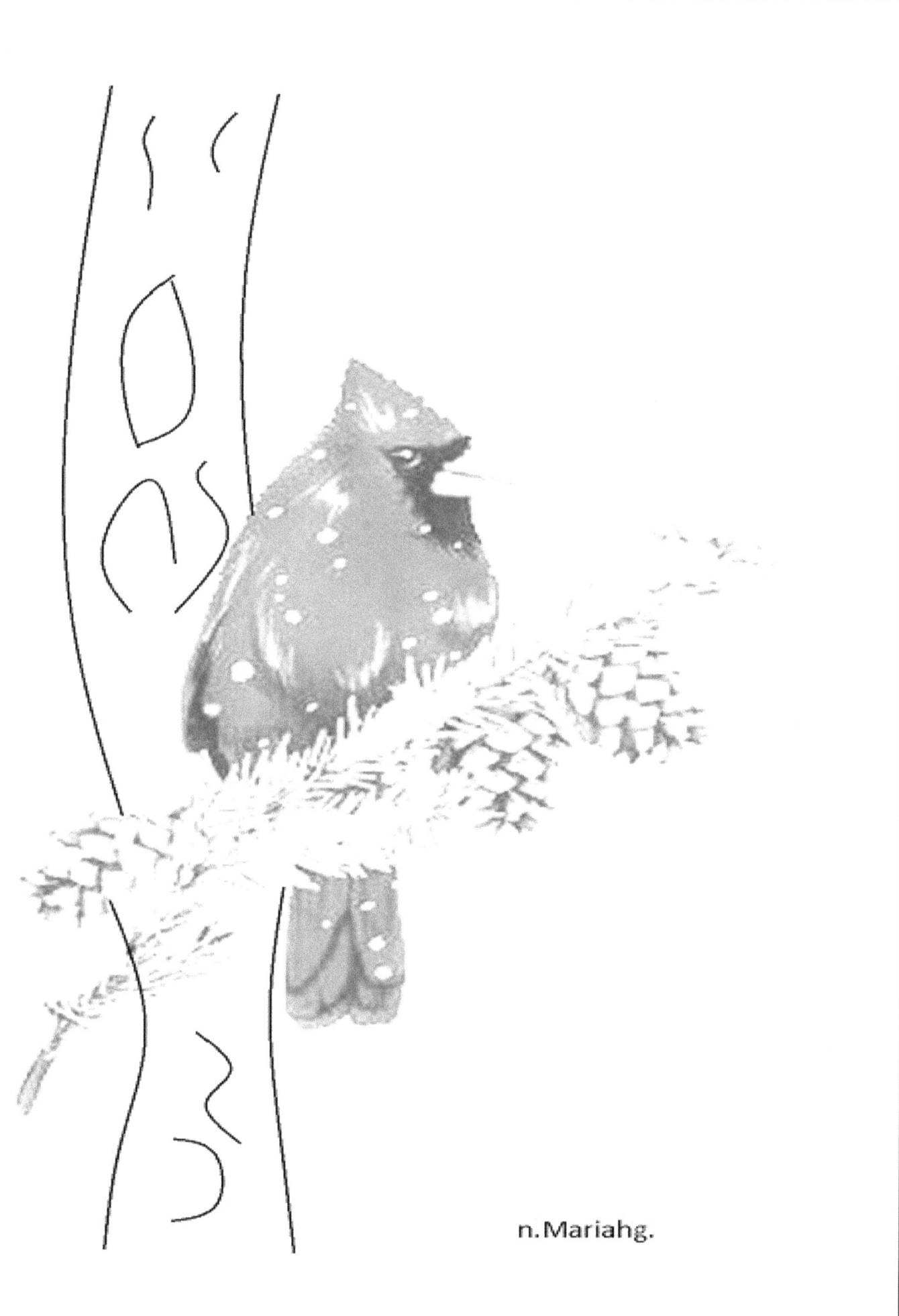

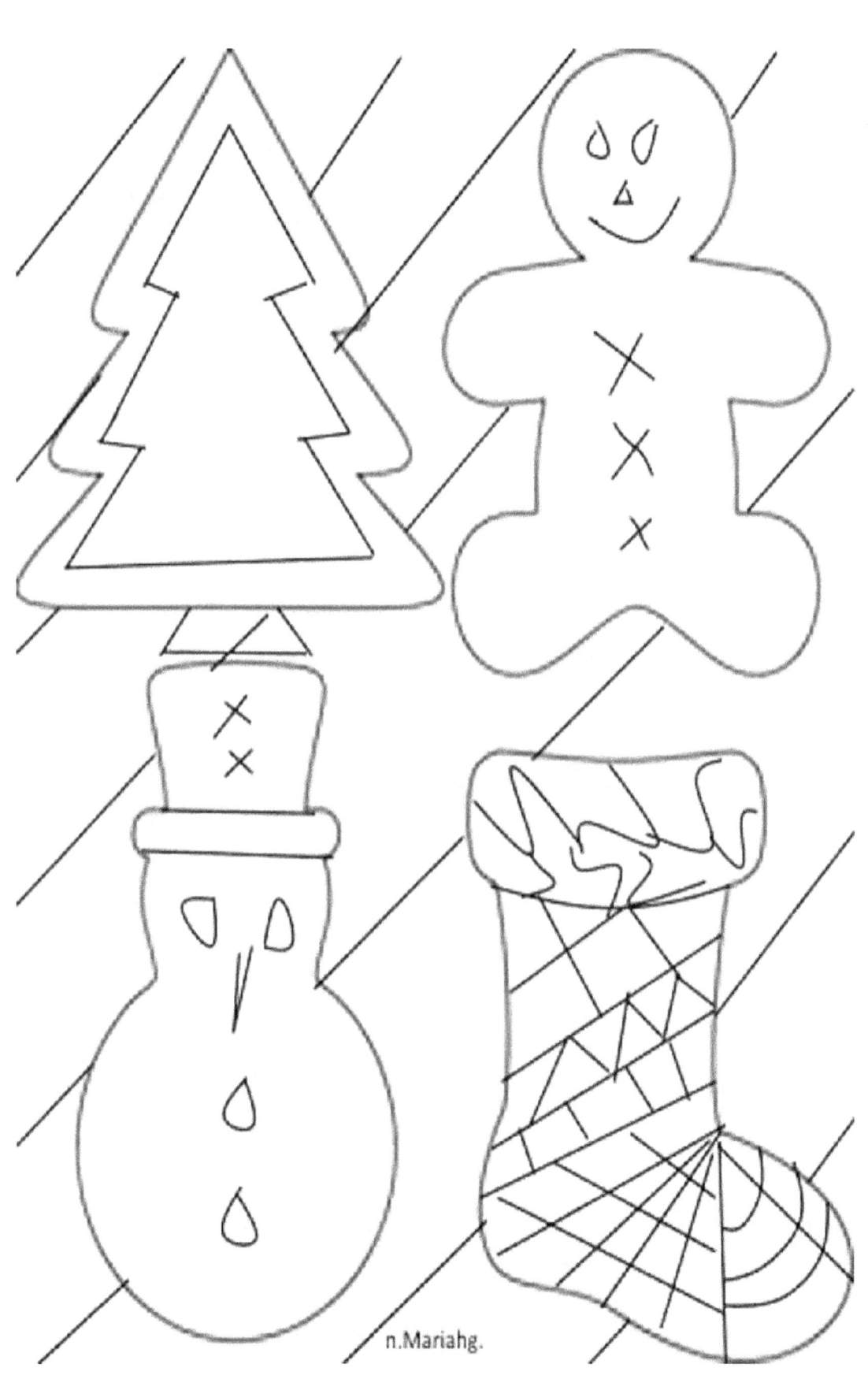

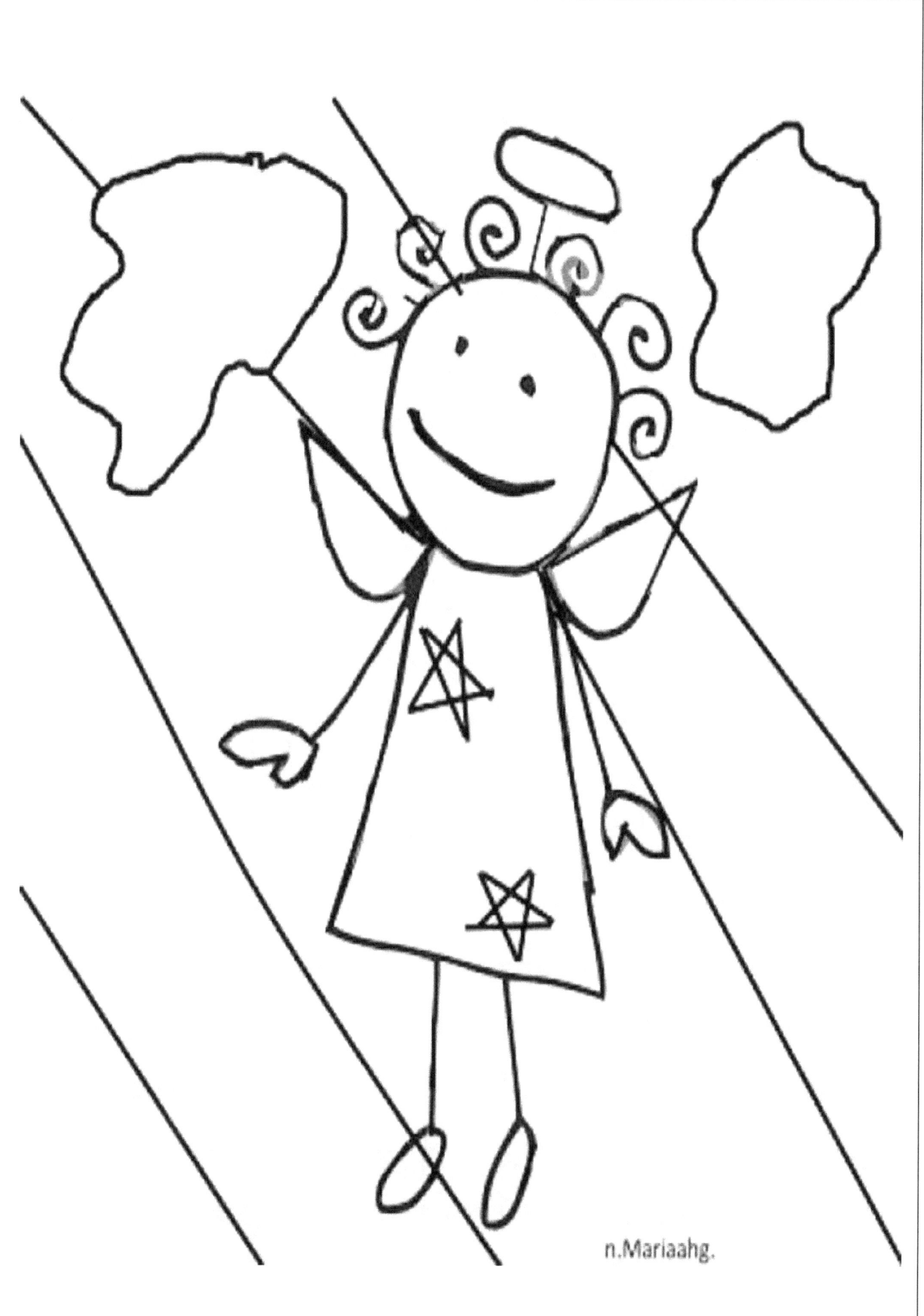

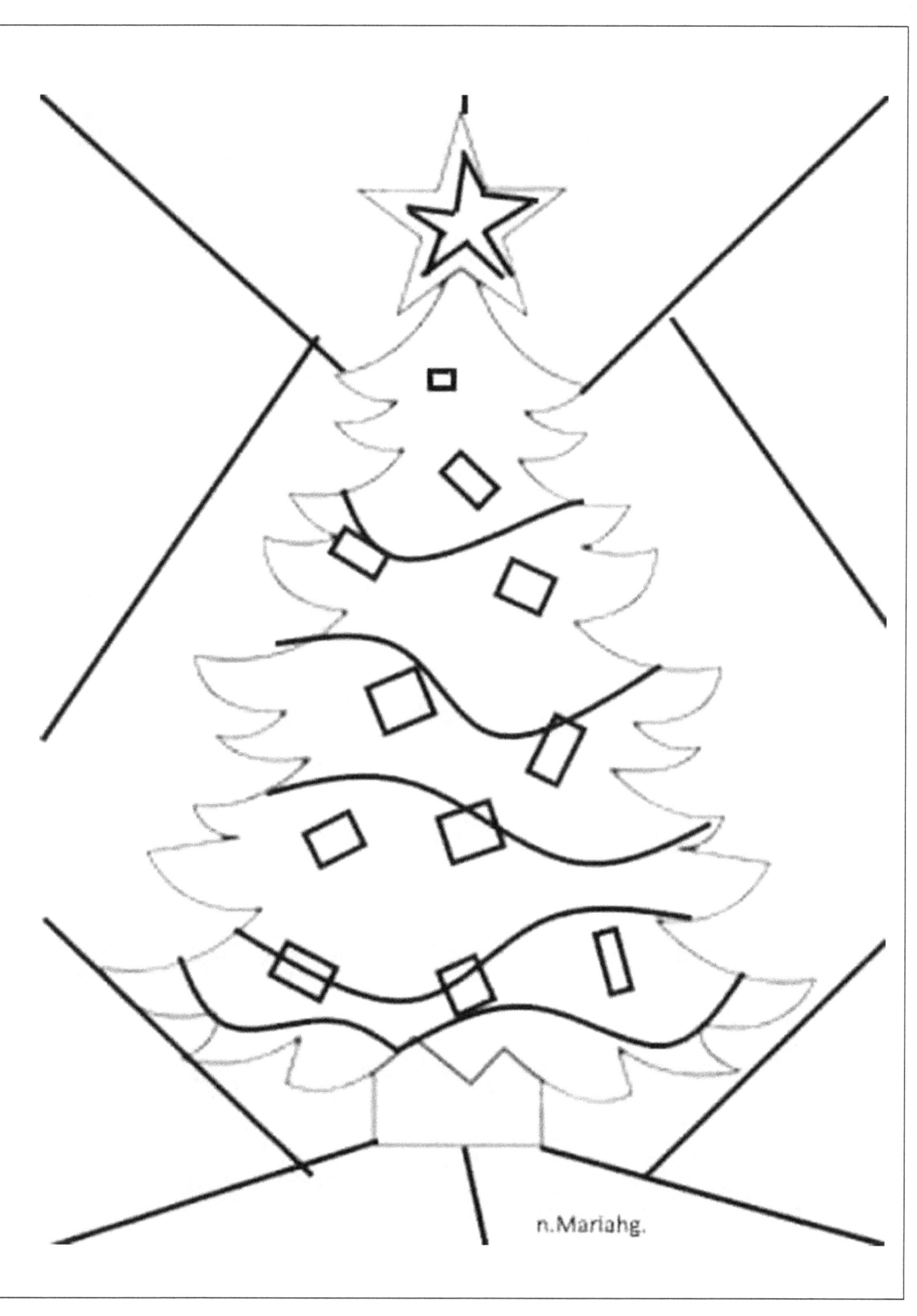

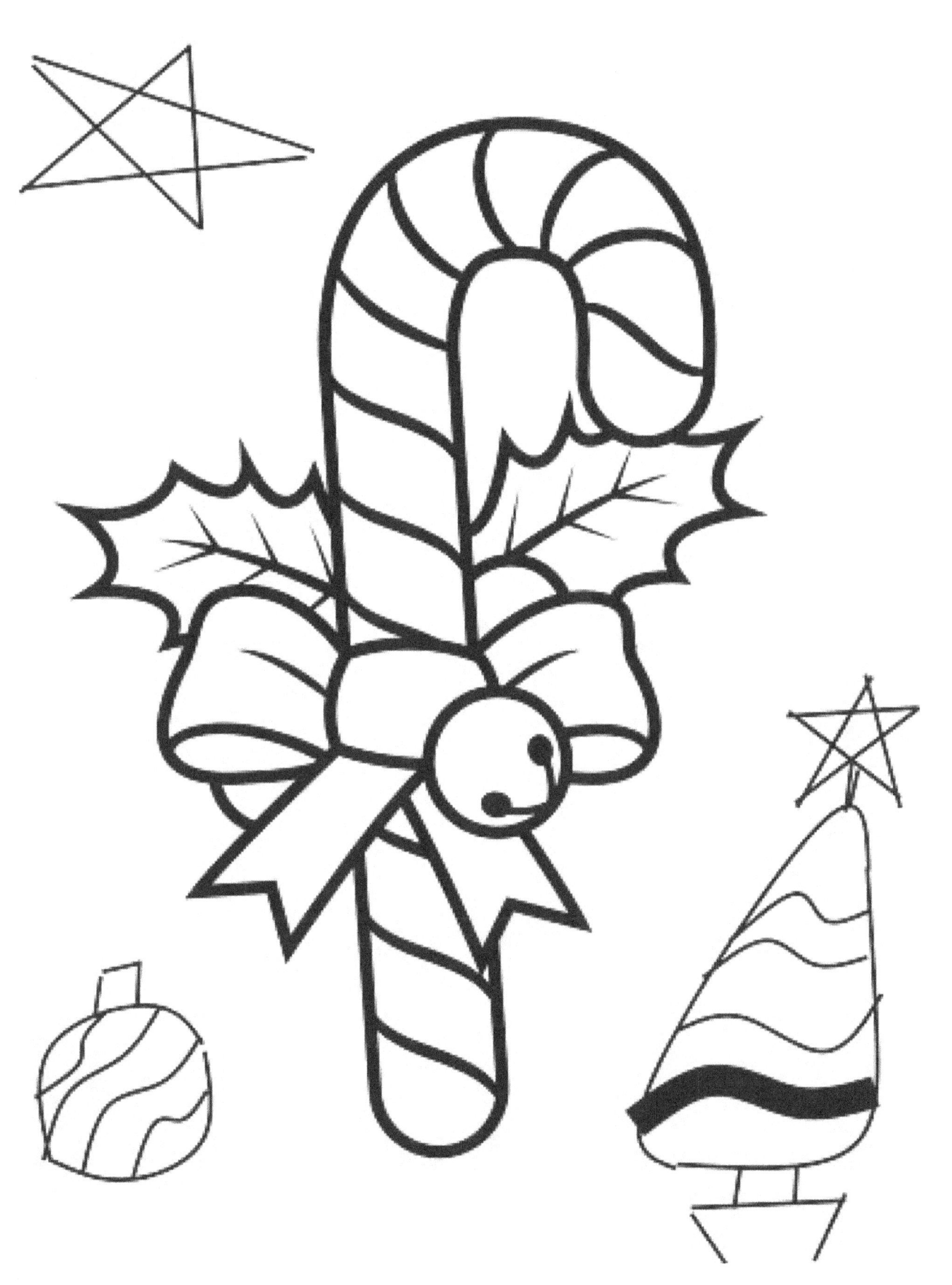

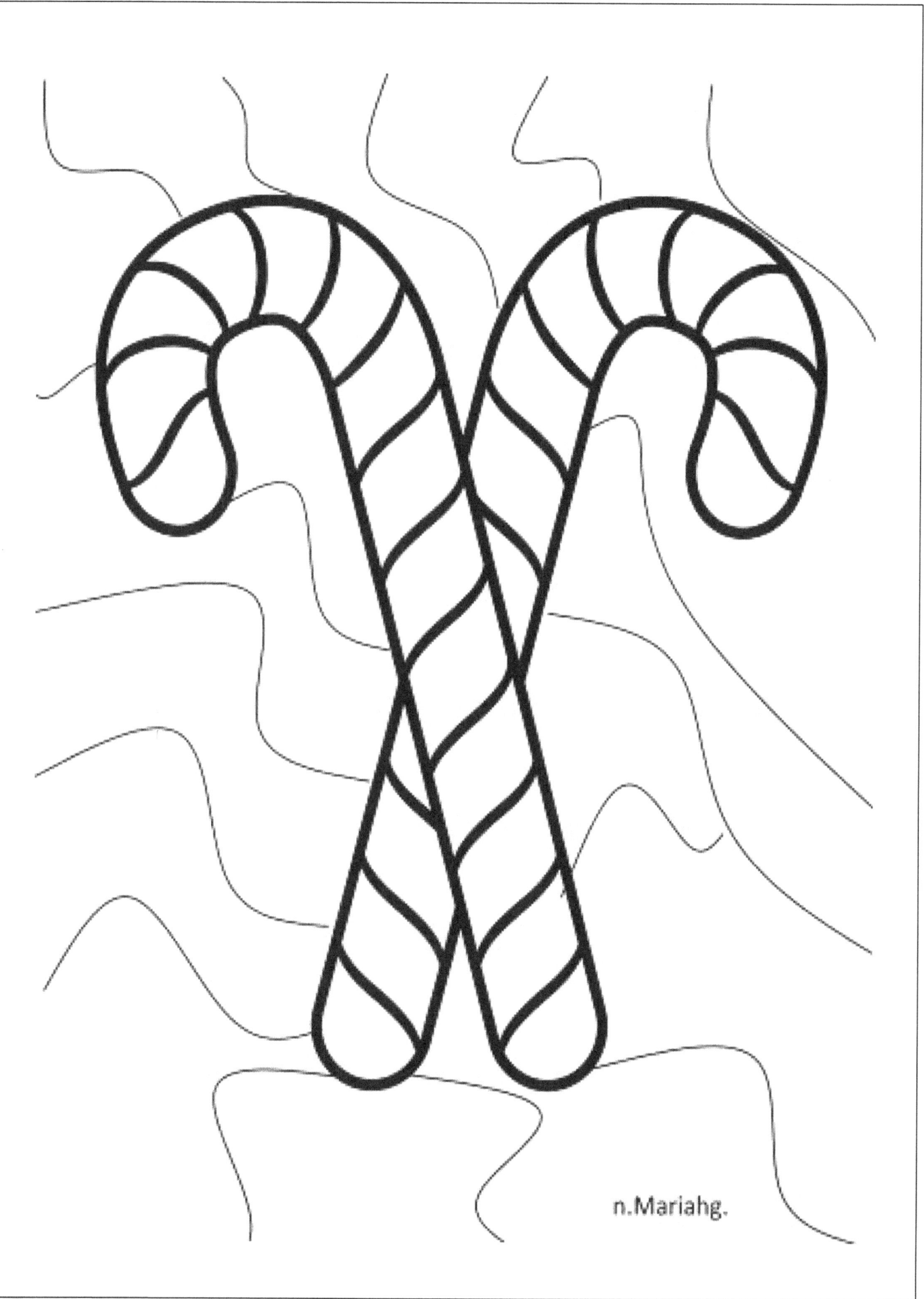

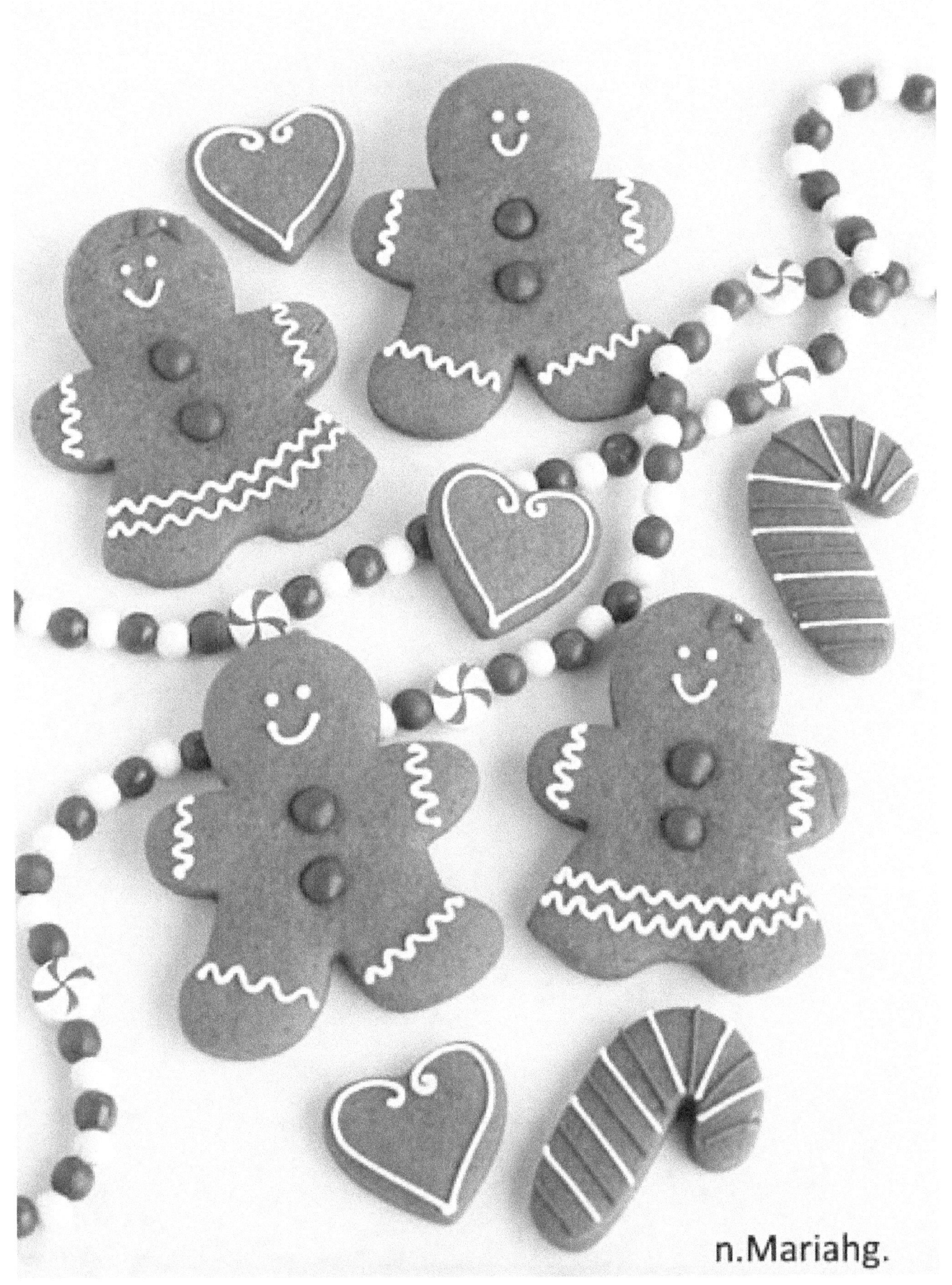

Print and draw JAWS

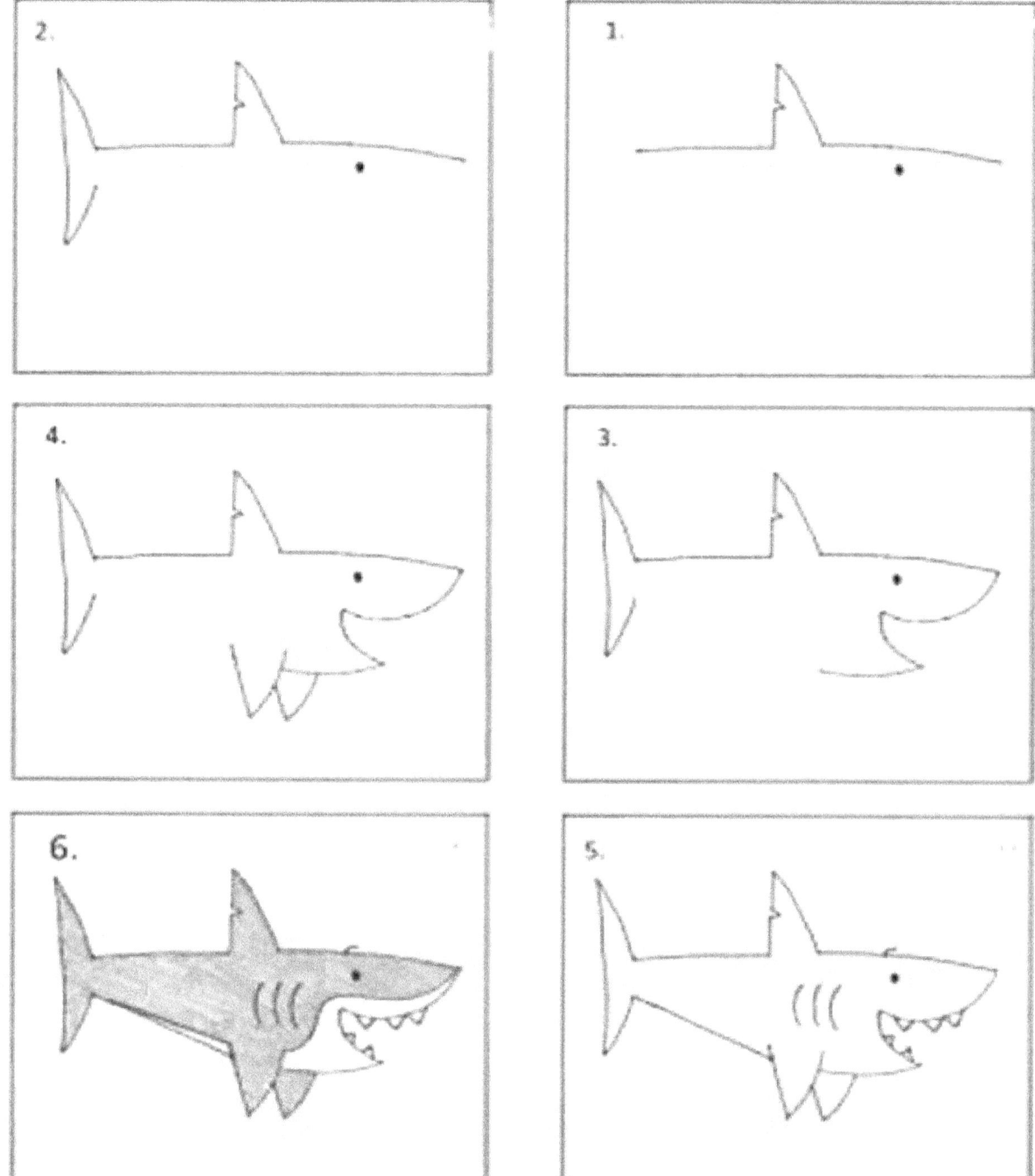

n.Mariahg.

Kiani Chandler

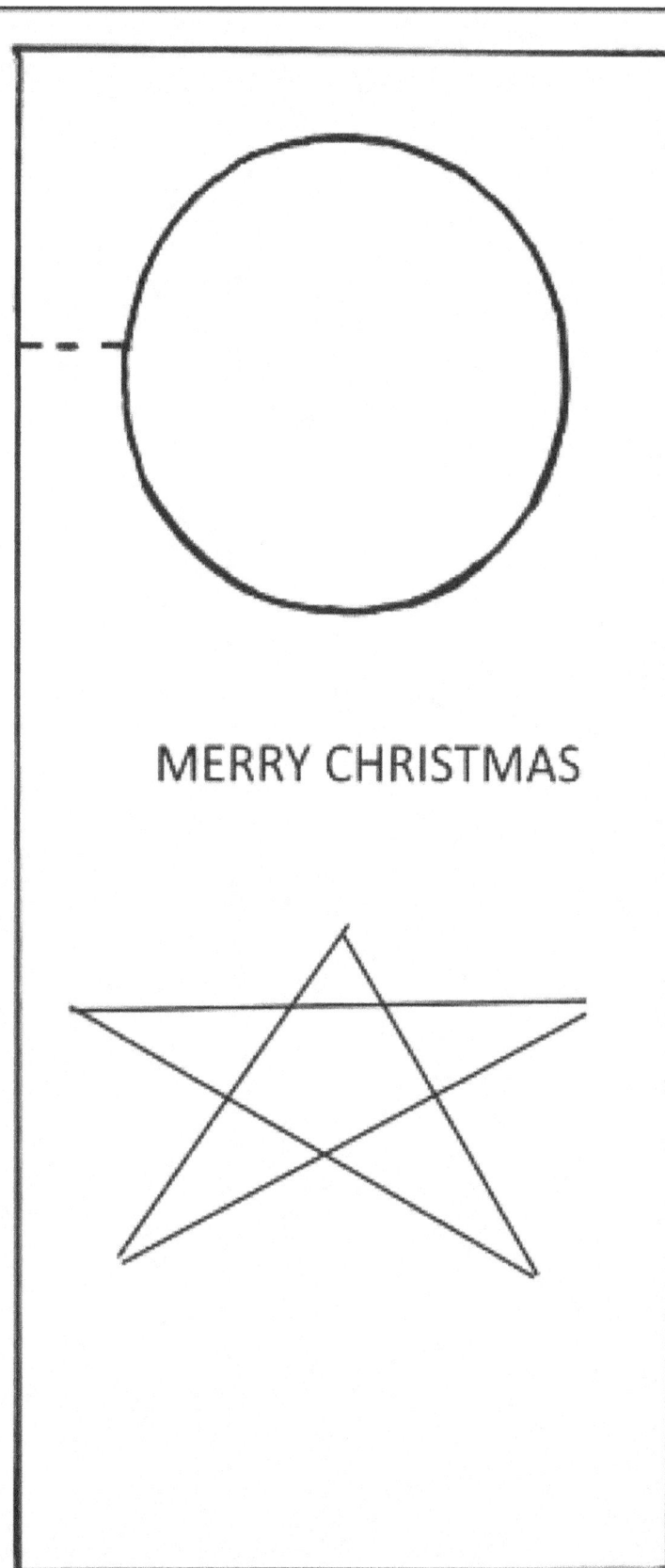

Door Hanger Template

Print on colored or plain cardstock, cut out around dark lines, flip over and decorate!

Cut along the small dotted line if circle doesn't fit on your doorknob.

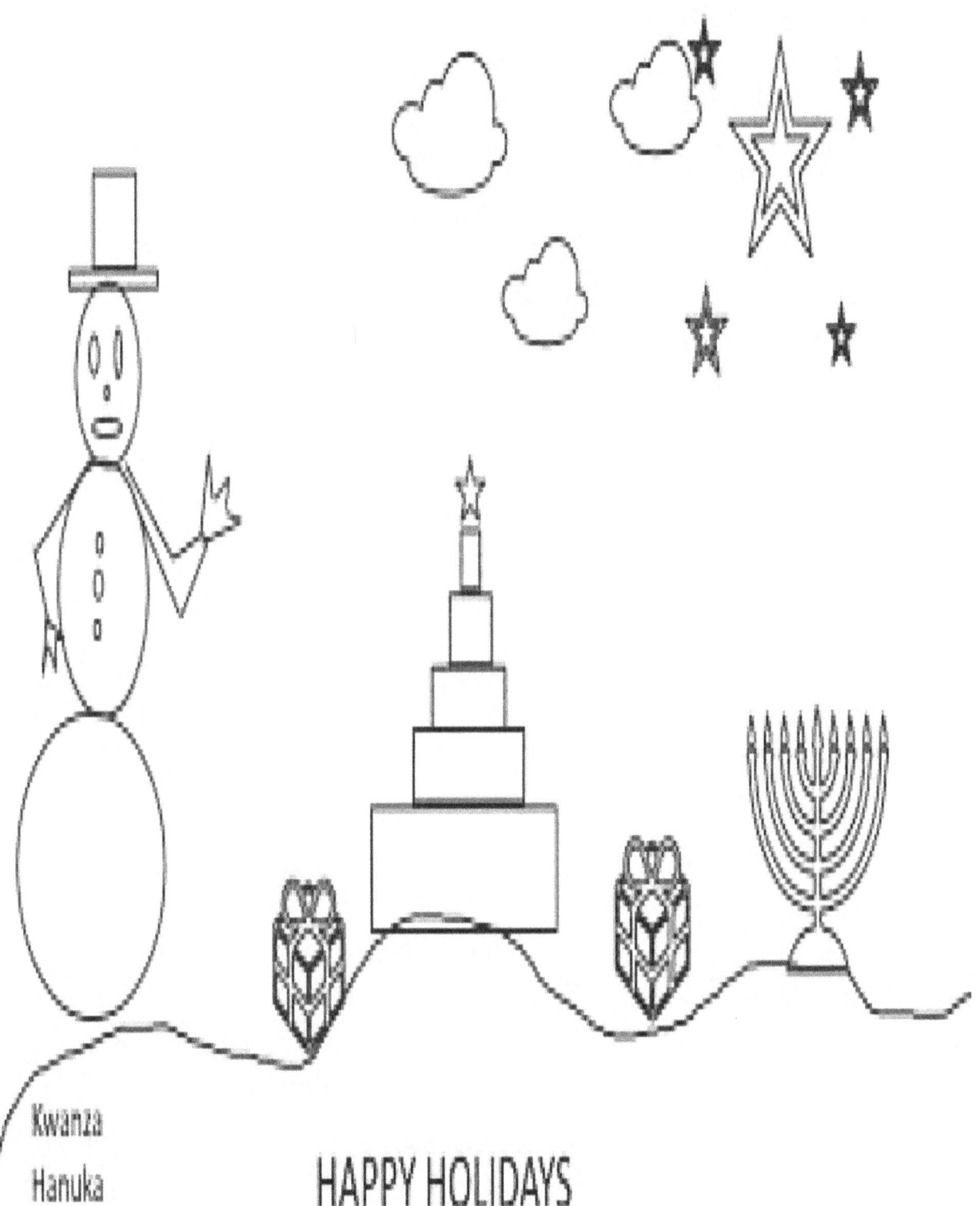

n.Mariahg.

n.Mariahg.

Merry Christmas
Kwanza
Hanukah

n.Manahg

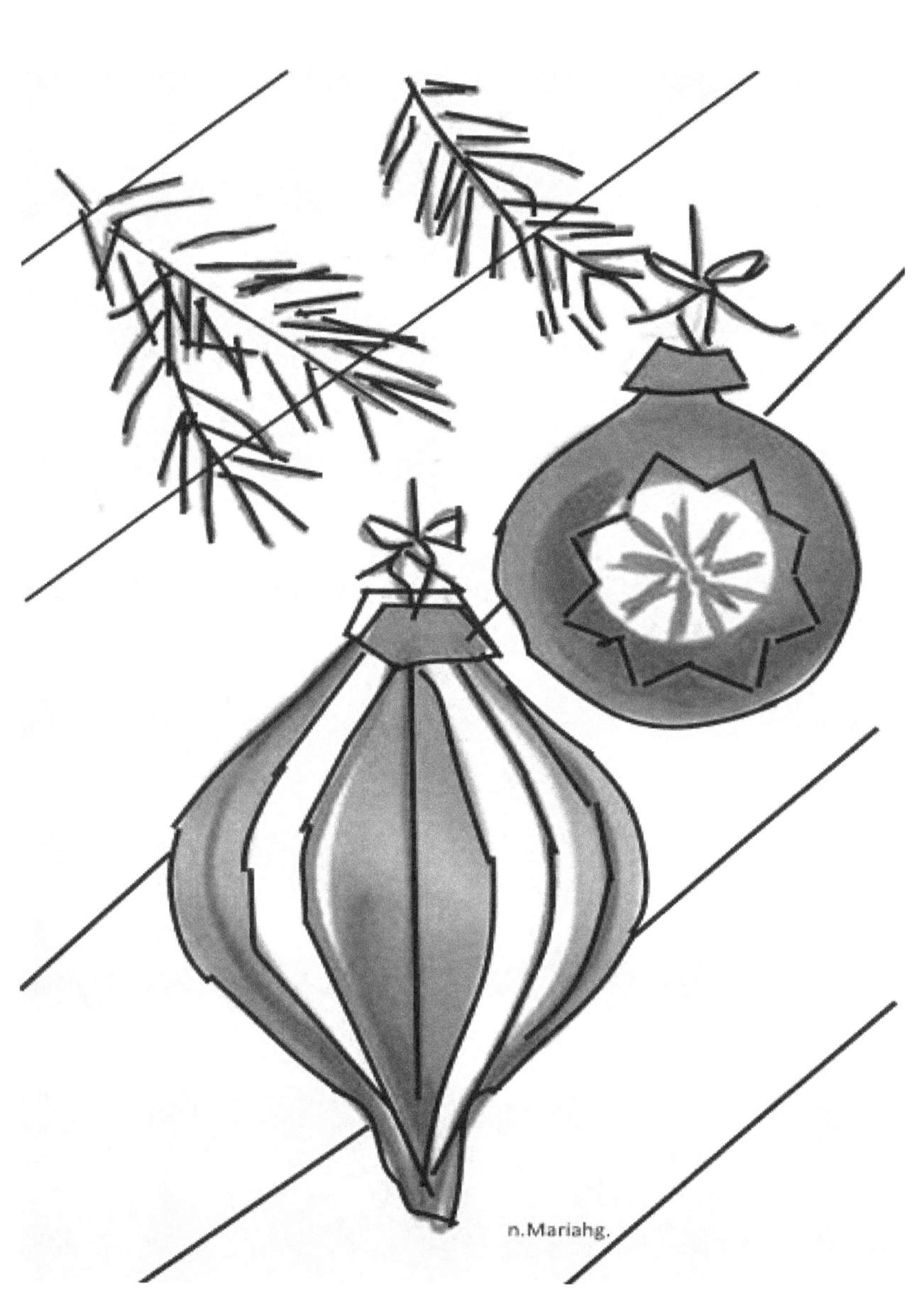

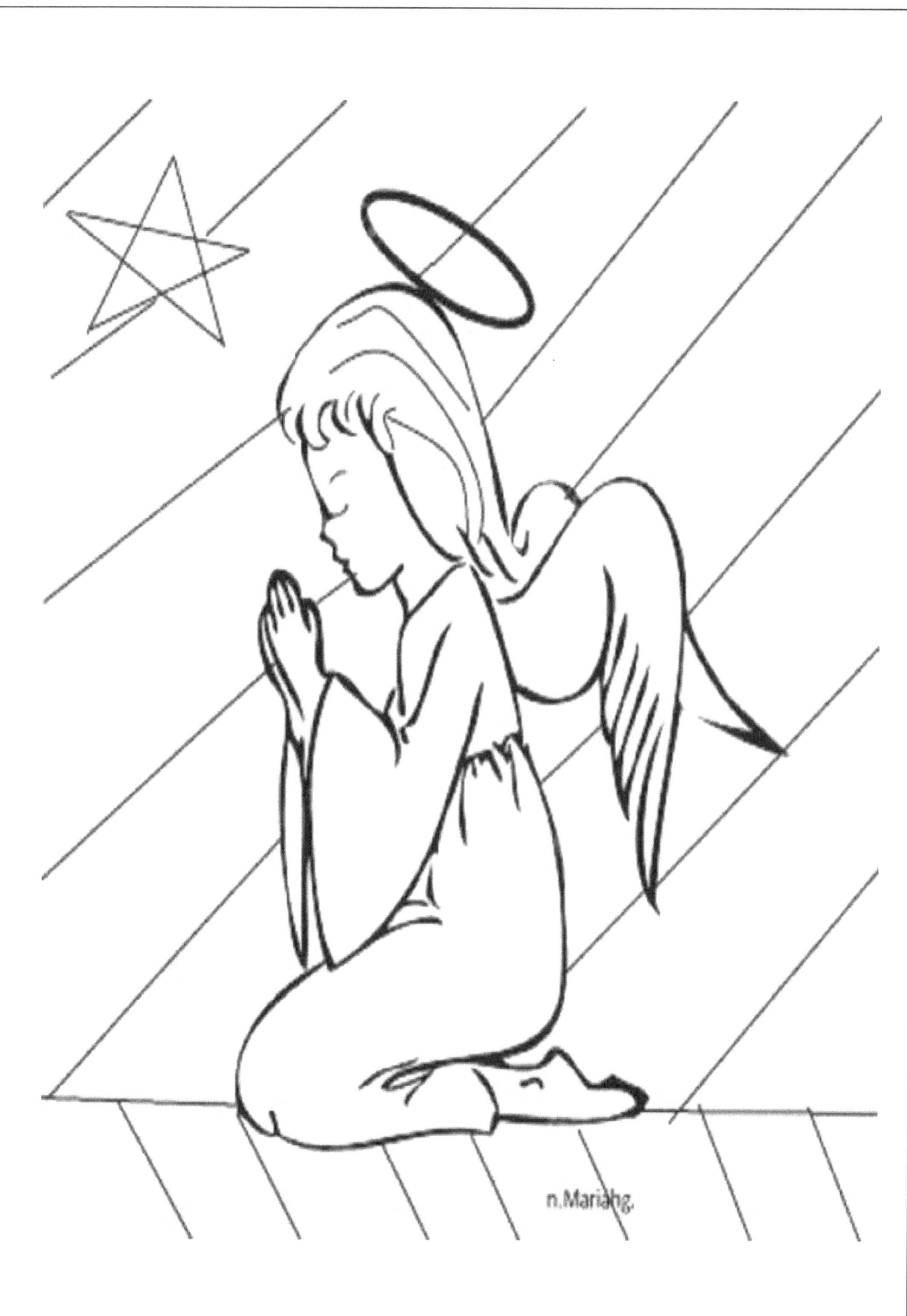

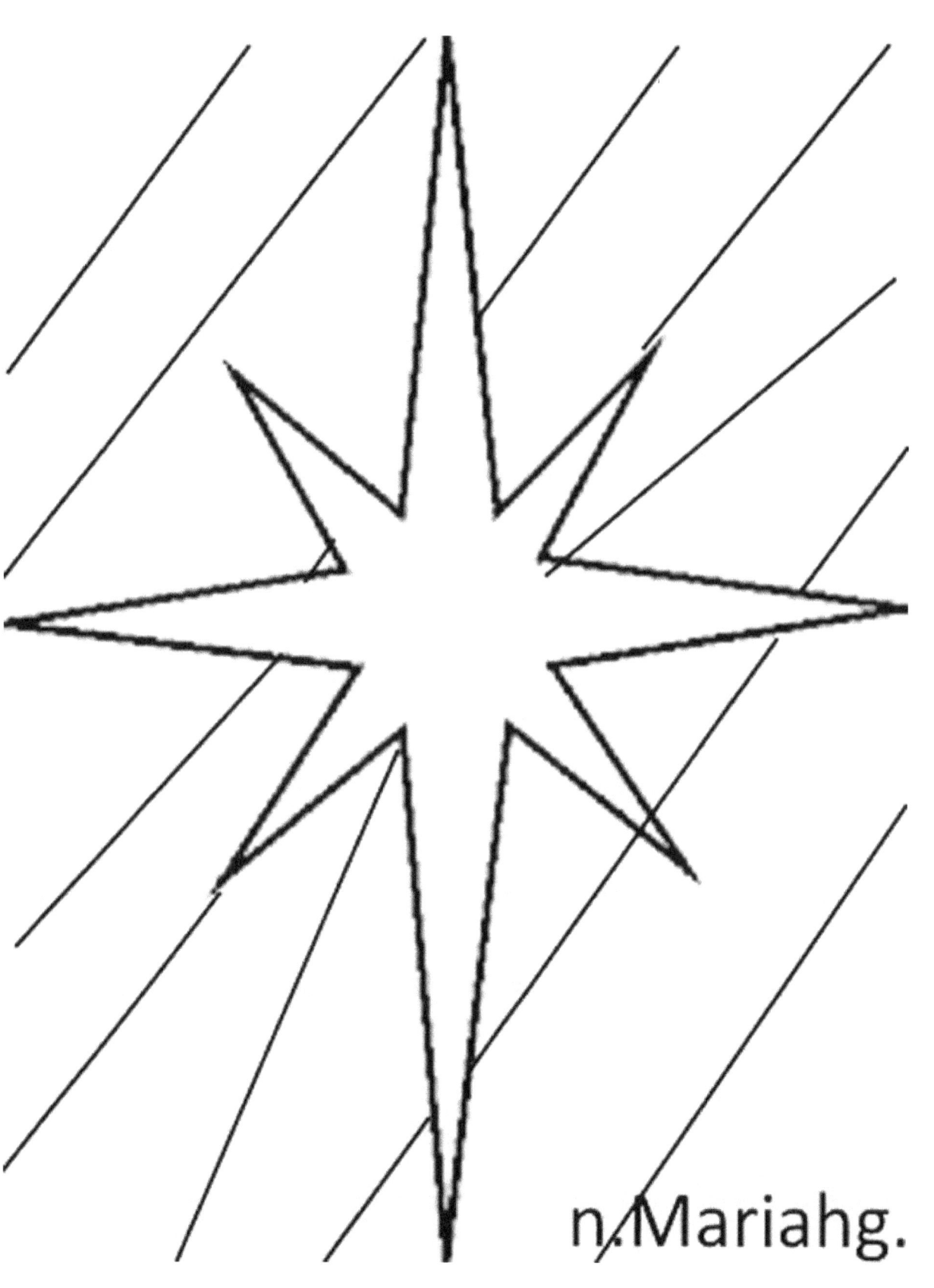

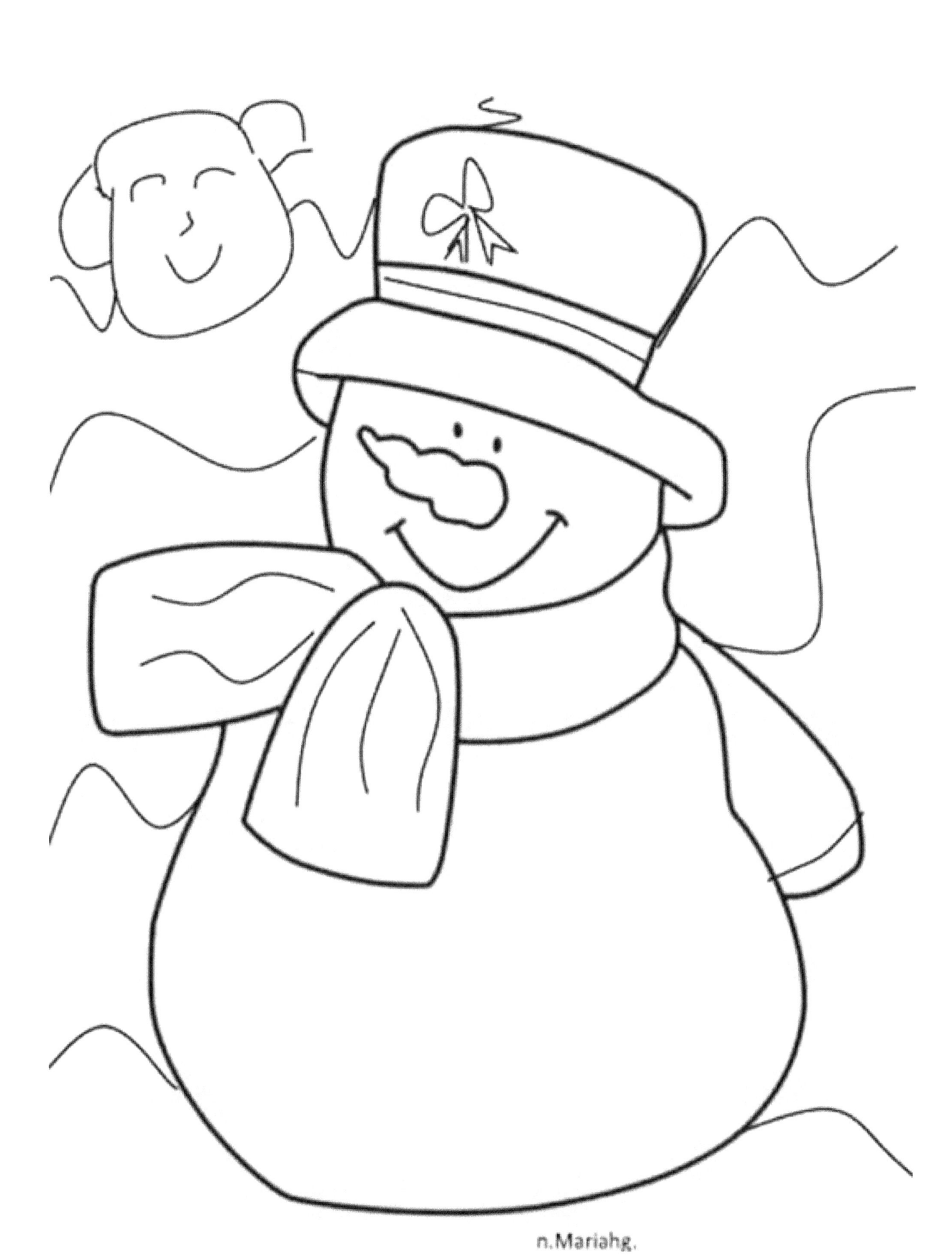
n.Mariahg.

n.Mariahg.

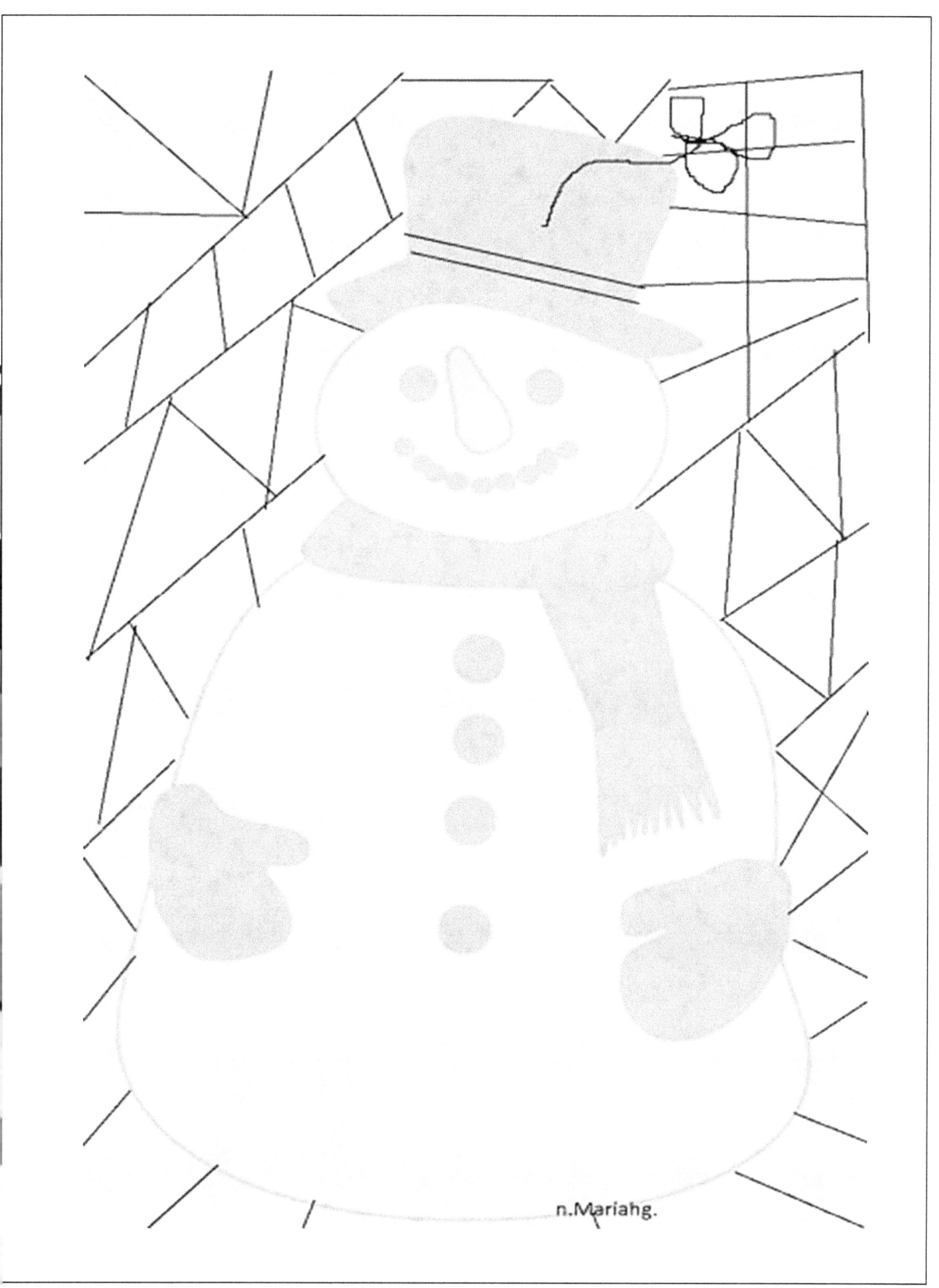

n.Mariahg.

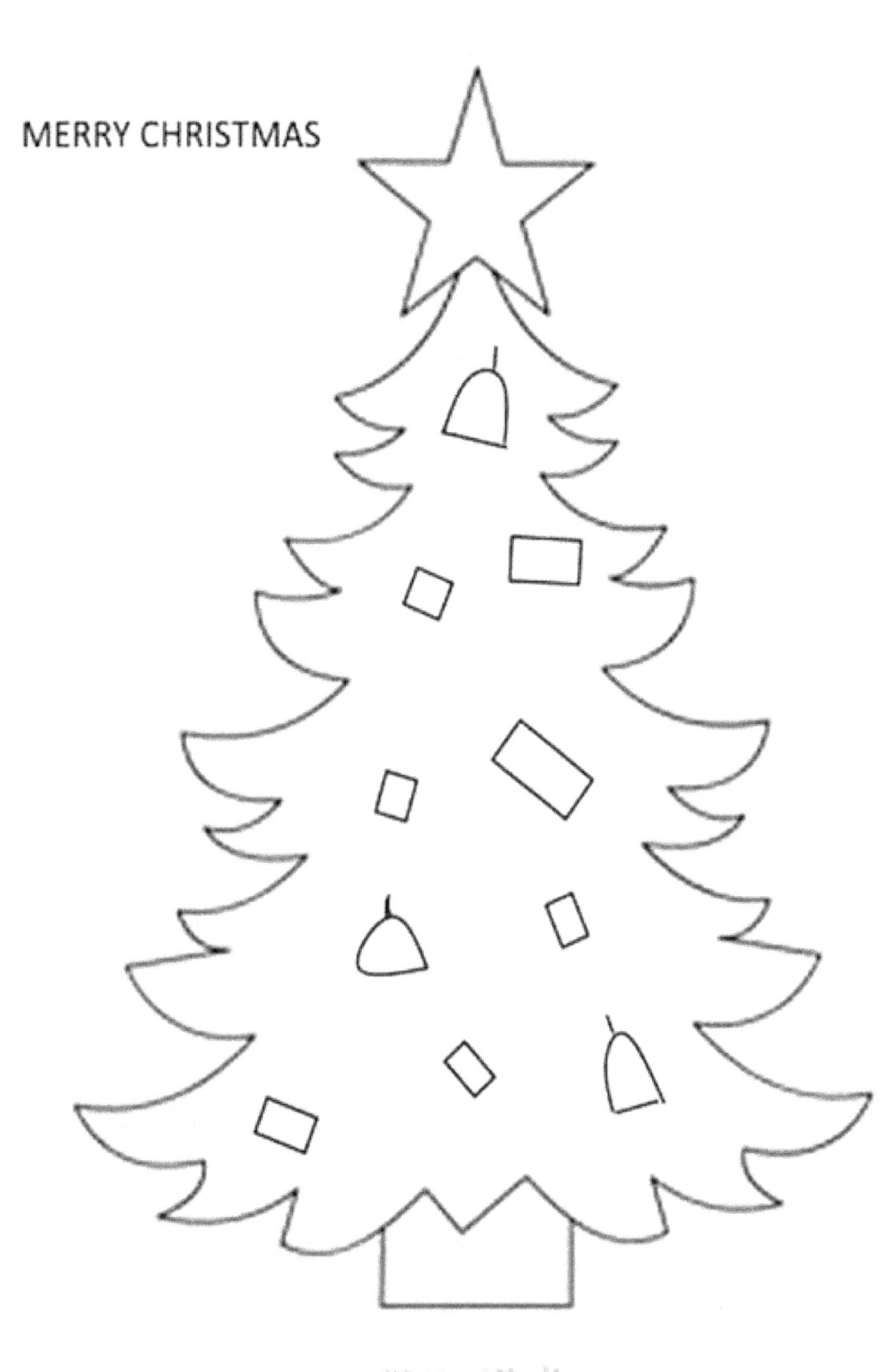

n.Mariahg.

HELP THE ELF GET TO THE GIFTS

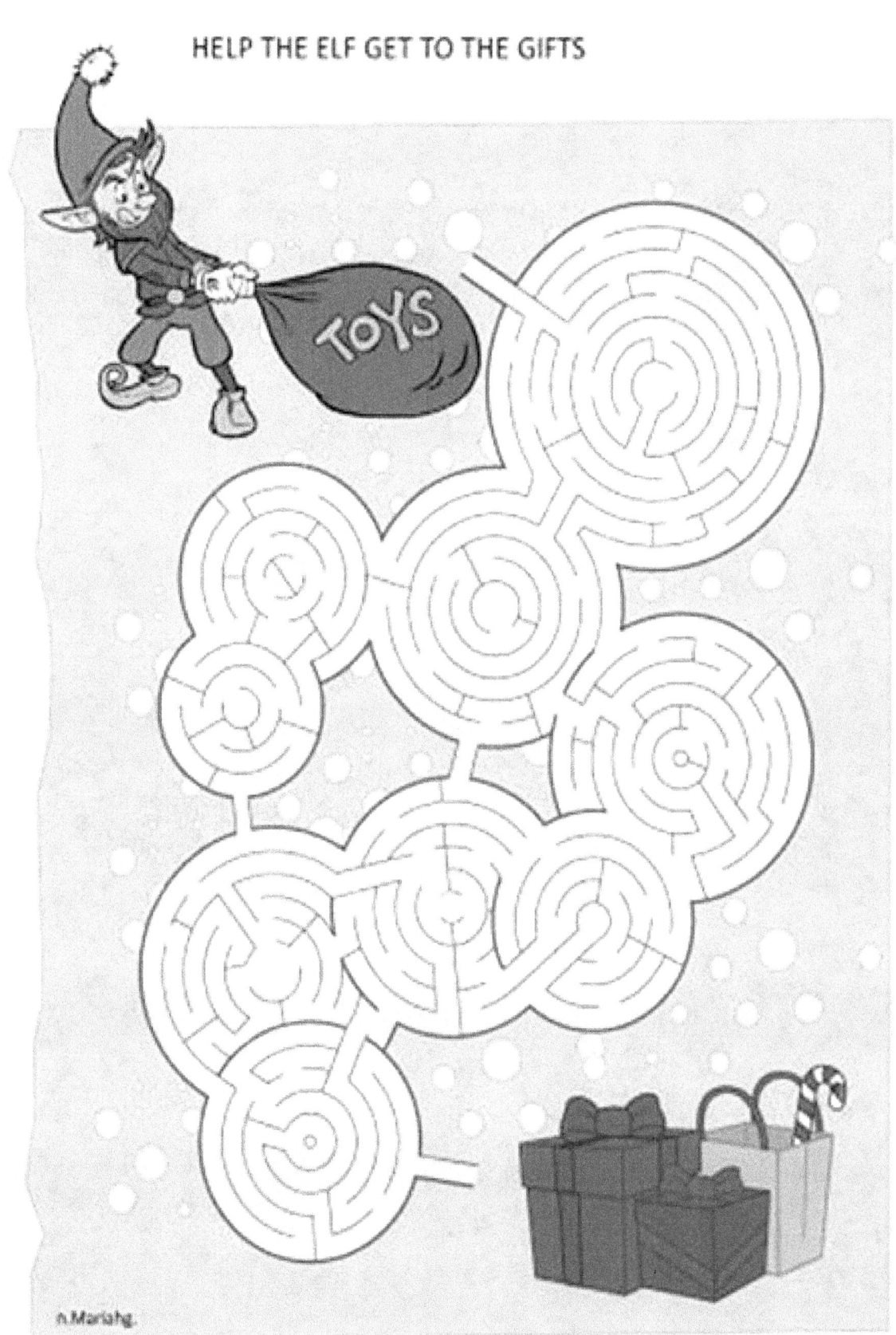

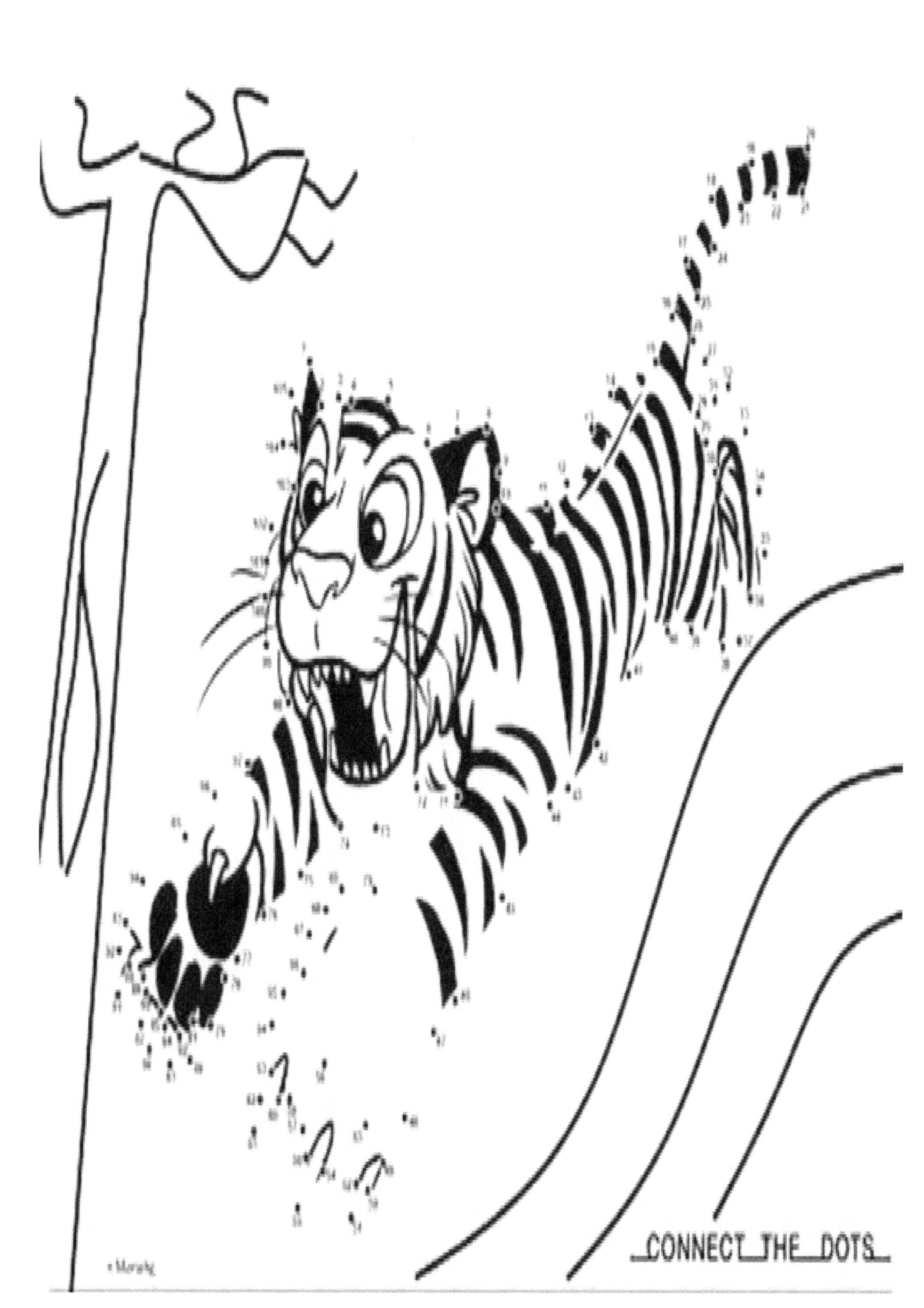

CONNECT THE DOTS

n.Mariahg.

COUNTING PRACTICE!

FIRST GRADE

NUMBERS 1 TO 10

Walt the brave knight is catching monsters in the forest. Draw as many teeth in the mouth of each monster to match the number on its back.

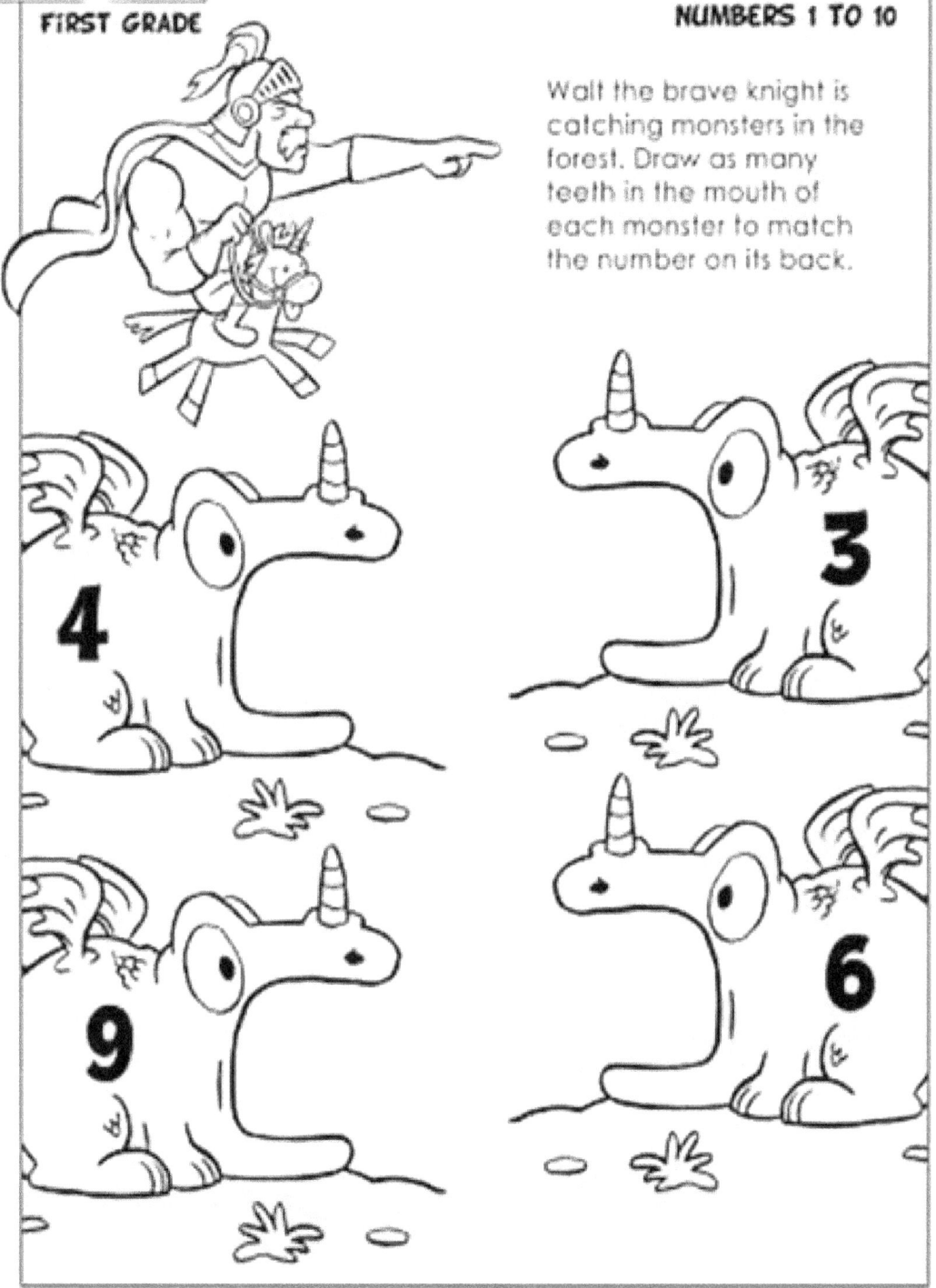

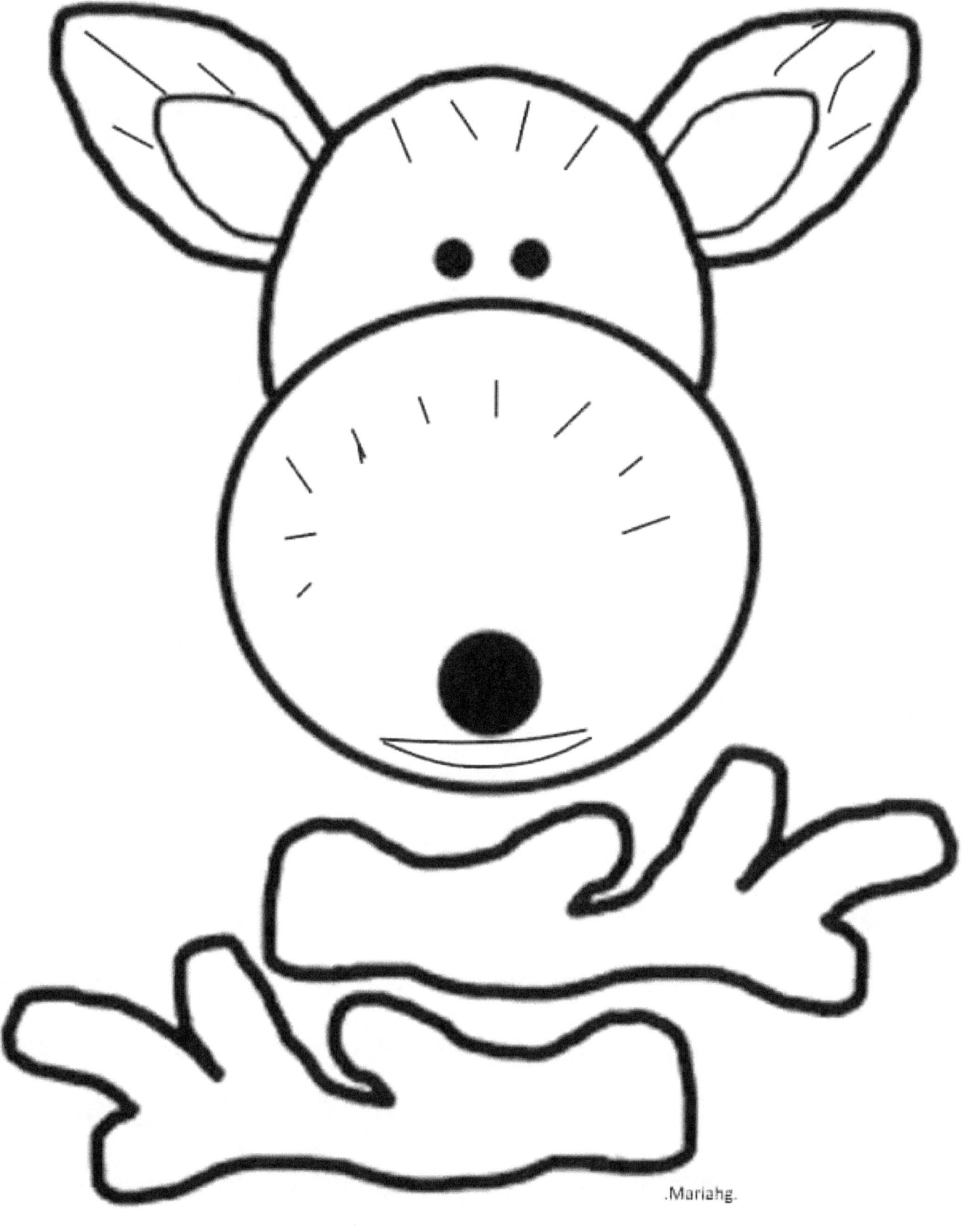

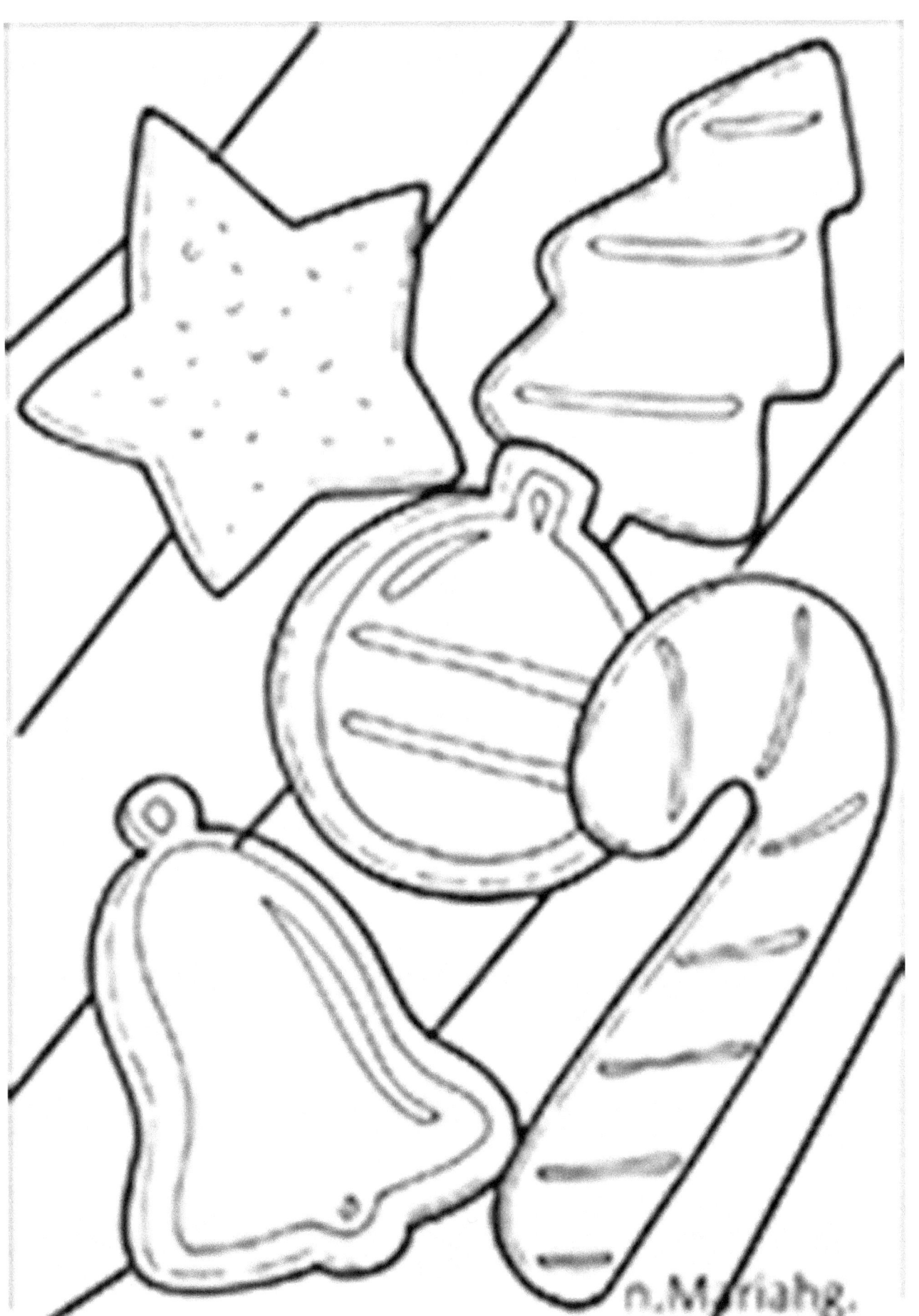

n.Mariahg.

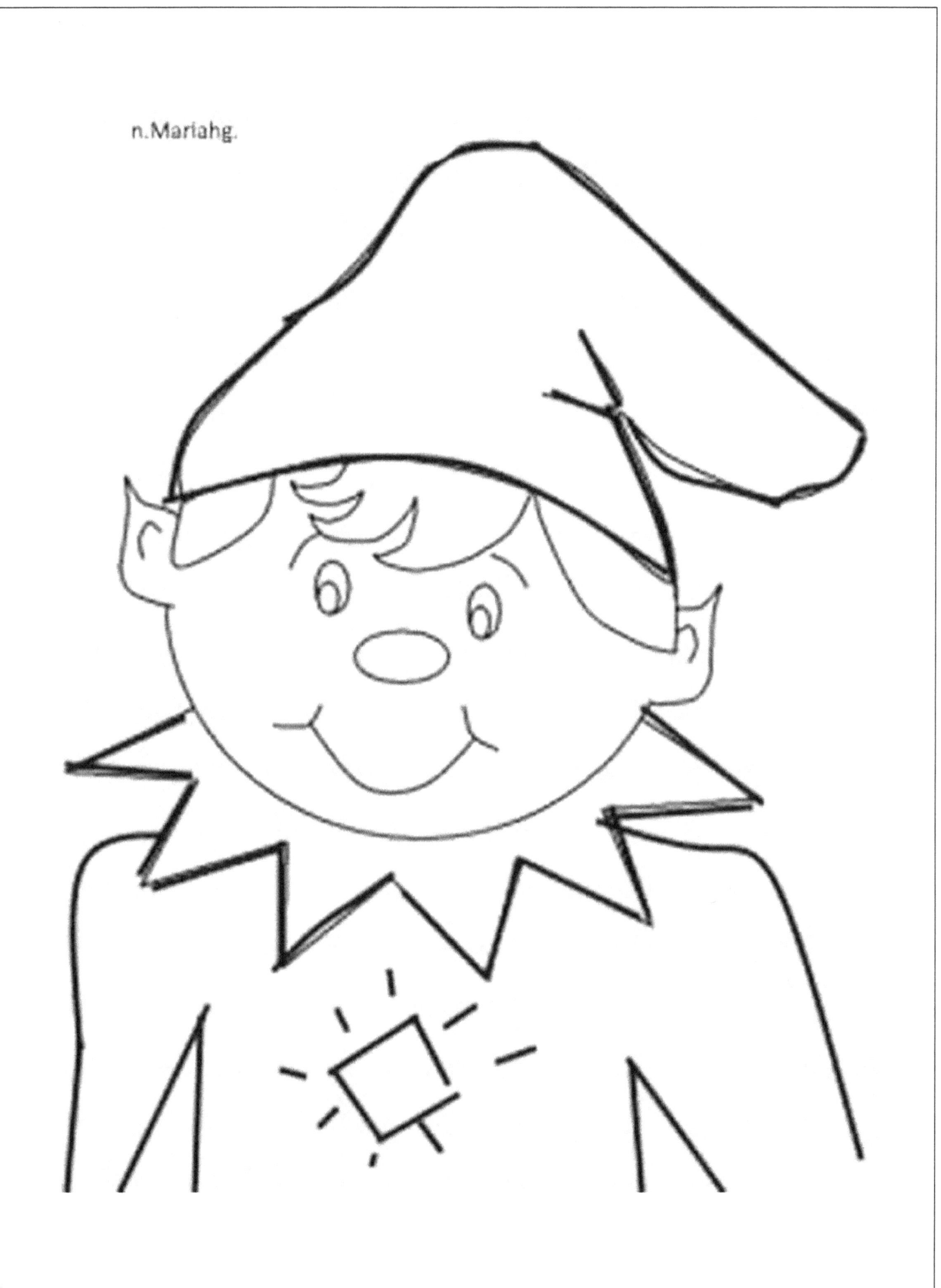

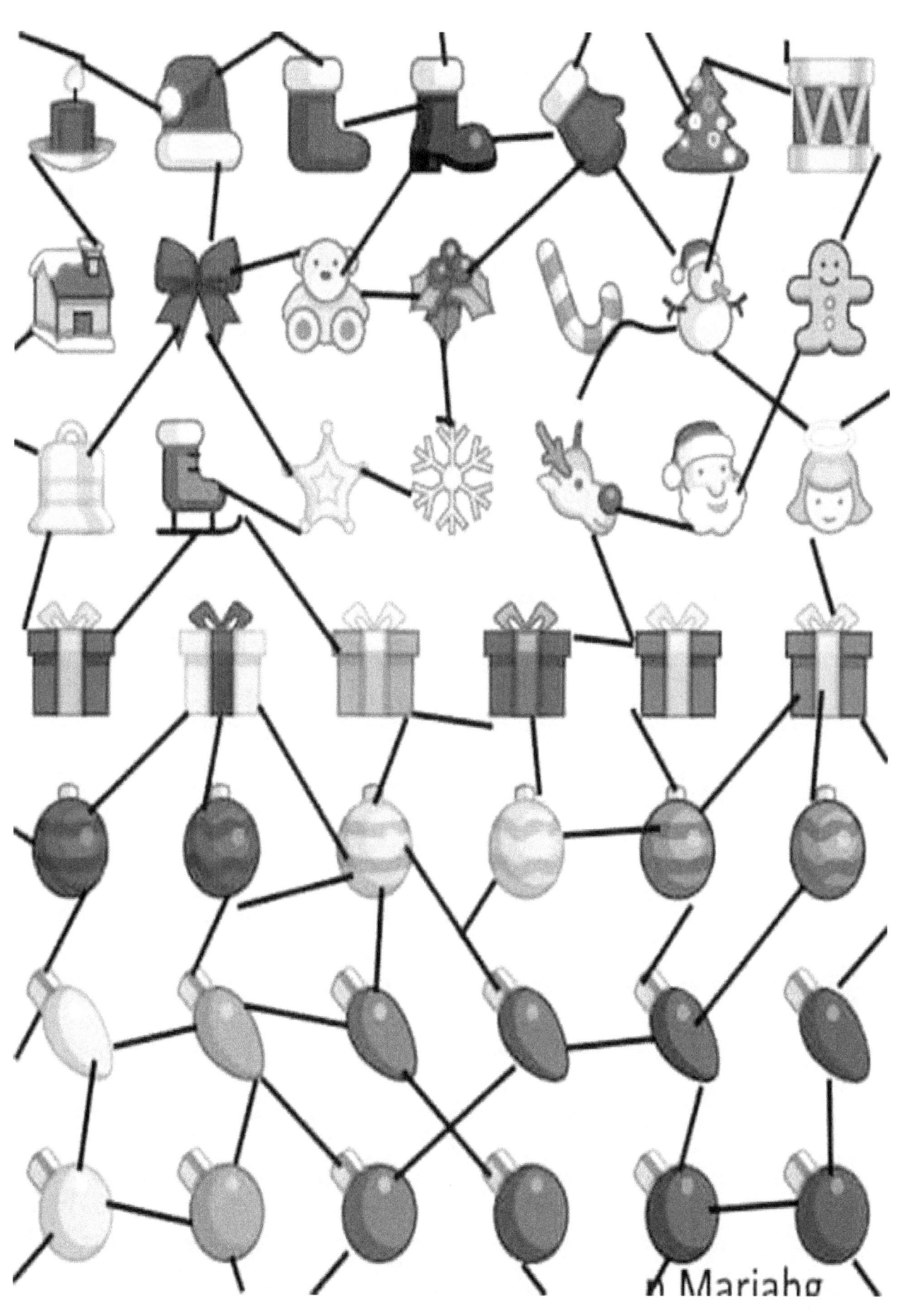

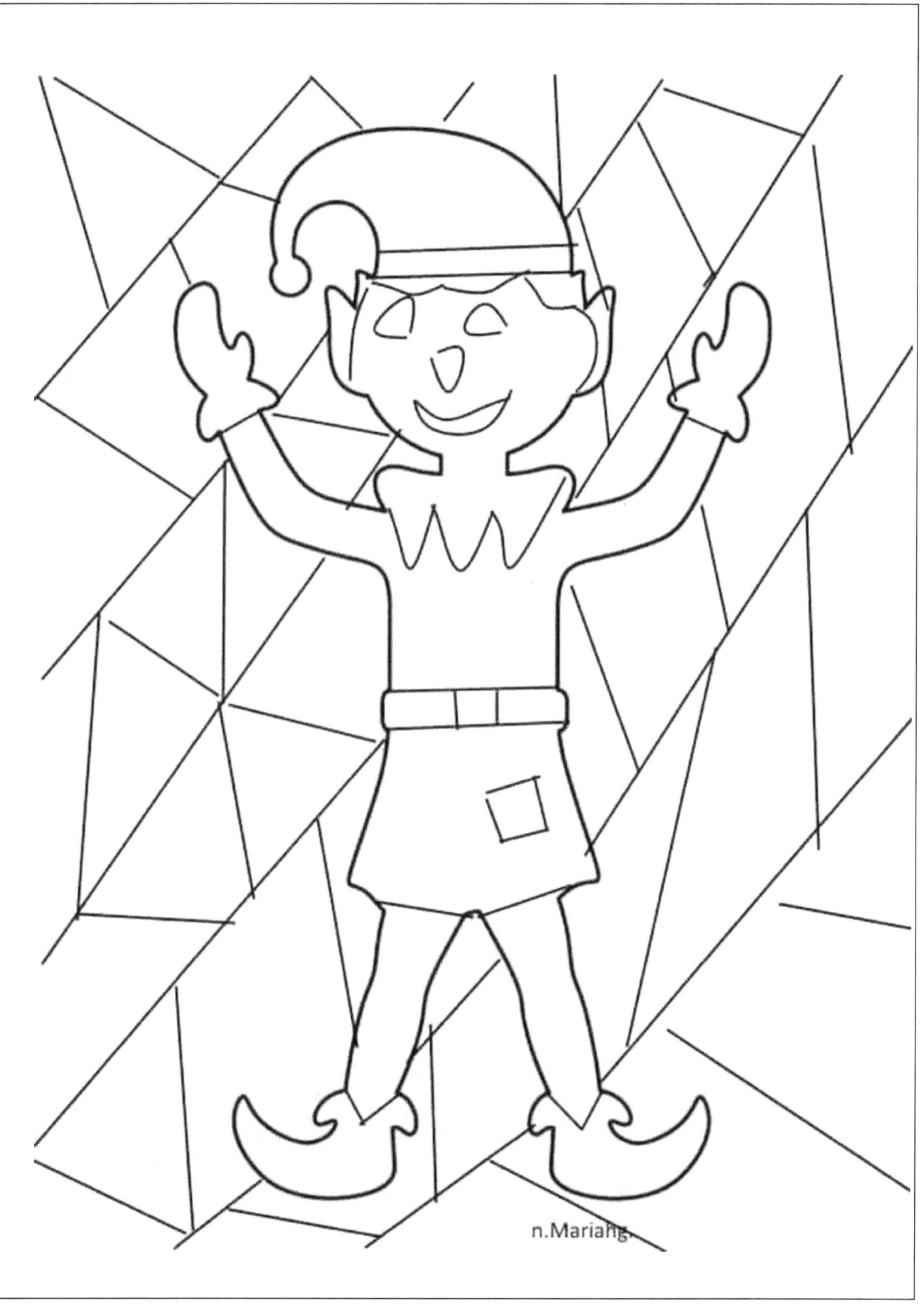

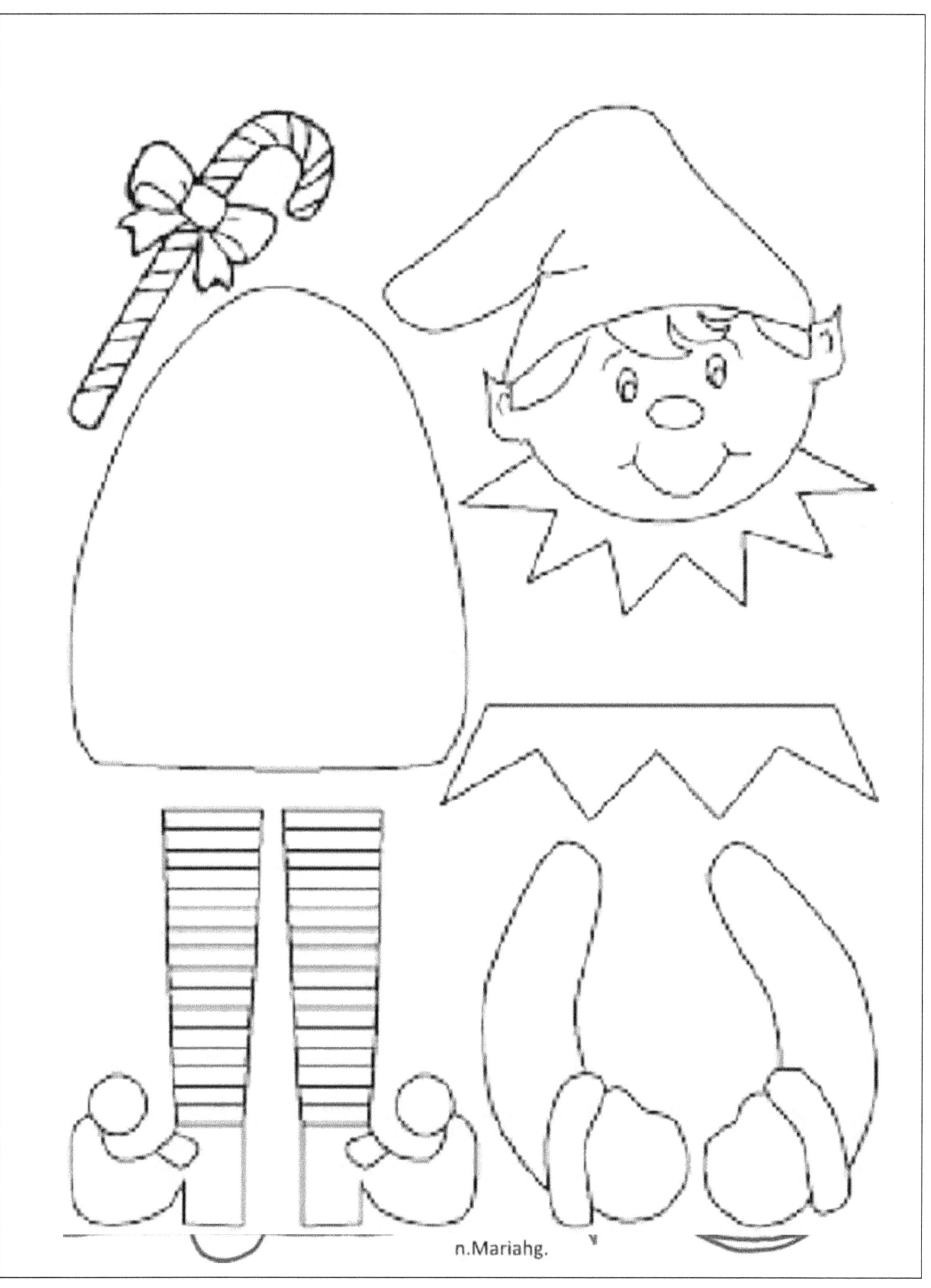

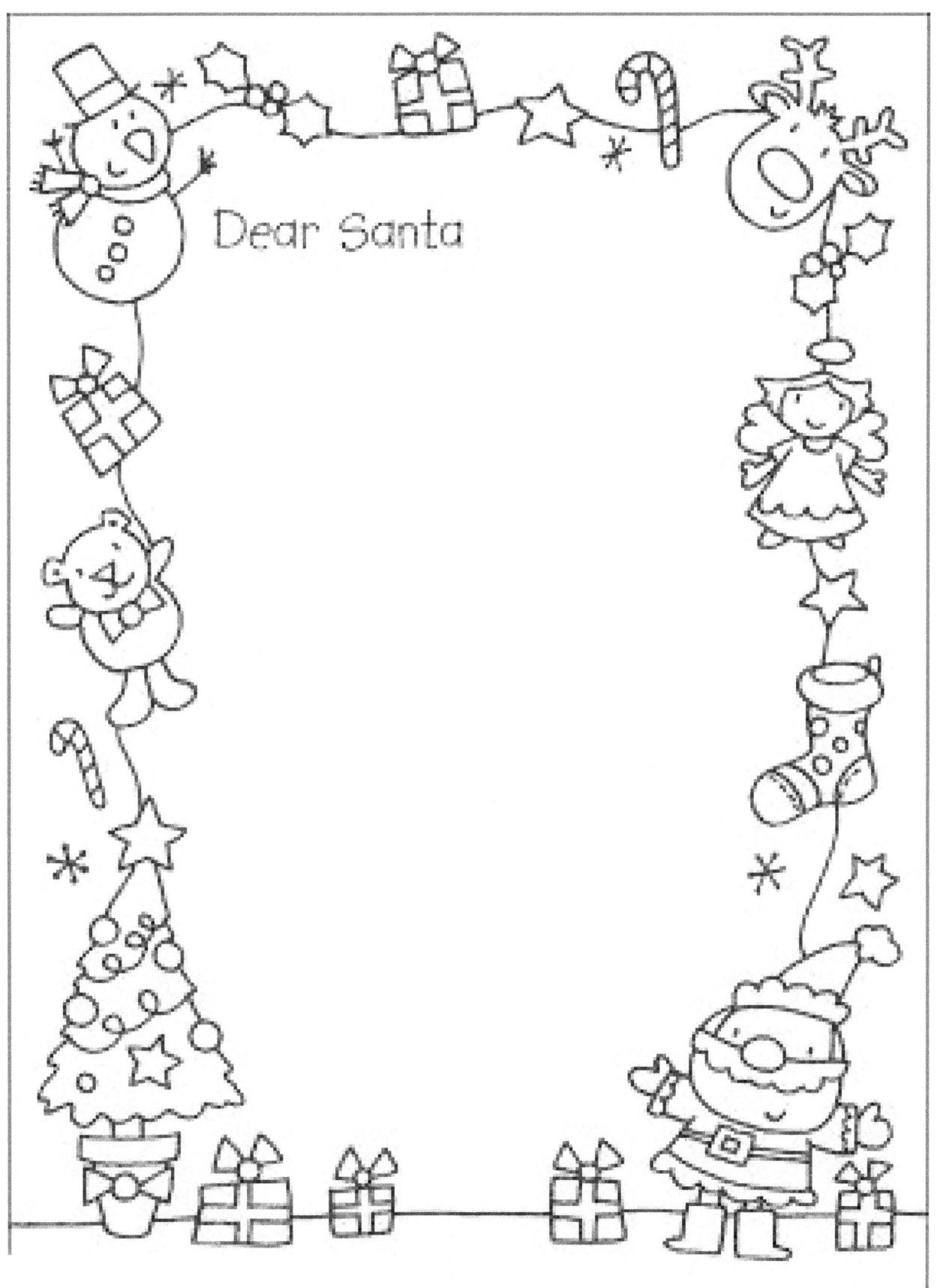

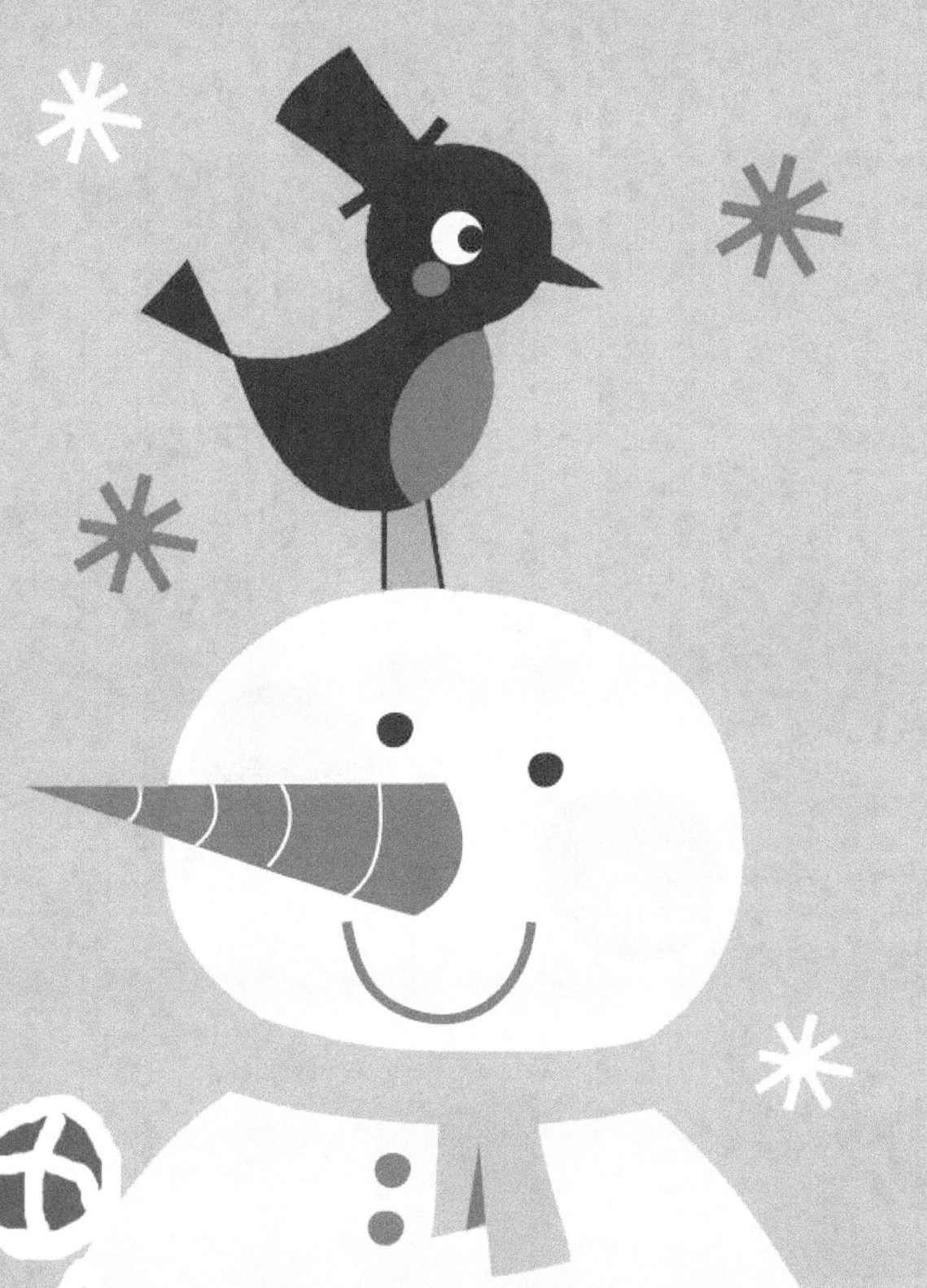

ABOUT THE ARTISTS

About the Artist: Nancy Graham..publishing under the pseudonym of

n. Mariah g., a current resident of New Port Richey, Fl. Was born in upstate New York, but has lived most of her life in Florida. She is now single, and lives with her only daughter and her family. She enjoys spending day, working on her art, and chatting with her friends on the internet. She loves her week ends, spent alternately, hanging out with her 2 grand children, or going to spend time with her gentleman friend. Ms. Graham, majored in business and art, all the way through to Art History The Renaissance Period.. She worked many years in management in the construction world, until she took early retirement due to her health. Although, like everyone..she has good days and bad days, she says her grand children and social life get her through the rough patches. At 61, she still has many plans to write and finish her bucket list. She got her Ba At Phoenix of Arizona. She also has her Masters in Theology. Follow me on Face Book https://www.facebook.com/GrahamMariah/ and My Web site http://nmgraham8611.wixsite.com/mysite-1, and sign up to my mailing list for updates on my work and free occasional downloads of new Art.

Kiani, is a ten-year-old girl with a love for art and music. And throw in some flag football. She can be all kid one minute and a mini adult the next. She lives with her parents, little brother and Grandmother!

www.ingramcontent.com/pod-product-compliance
Lightning Source LLC
Chambersburg PA
CBHW081151180526
45170CB00006B/2030